MY FIRST BOOK
A Tom Arma Baby Journal

This book belongs to

born on

[Paste photo here]

MY MOM'S FAMILY TREE

MOM

Name _____
Birth date _____
Birthplace _____

GRANDMA

Name _____
Birth date _____
Birthplace _____

GRANDPA

Name _____
Birth date _____
Birthplace _____

GRANDMA'S MOM

Name _____
Birth date _____
Birthplace _____

GRANDPA'S MOM

Name _____
Birth date _____
Birthplace _____

GRANDMA'S DAD

Name _____
Birth date _____
Birthplace _____

GRANDPA'S DAD

Name _____
Birth date _____
Birthplace _____

MY DAD'S FAMILY TREE

DAD

Name _____
Birth date _____
Birthplace _____

GRANDMA

Name _____
Birth date _____
Birthplace _____

GRANDPA

Name _____
Birth date _____
Birthplace _____

GRANDMA'S MOM

Name _____
Birth date _____
Birthplace _____

GRANDPA'S MOM

Name _____
Birth date _____
Birthplace _____

GRANDMA'S DAD

Name _____
Birth date _____
Birthplace _____

GRANDPA'S DAD

Name _____
Birth date _____
Birthplace _____

MY MOM

Here is a photo of my mom:

My mom's full name is _____

She was born on _____ in _____

Her height is _____ , her eye color is _____ , and her hair color is _____

She has _____ sisters and _____ brothers and they were born in this order:

She grew up in _____ and went to these schools:

After school, she _____

When my mom was a young woman, she dreamed of _____

Some of my mom's favorite things are:

artist _____

book _____

color _____

film _____

flower _____

hobby _____

holiday _____

place _____

play _____

season _____

song _____

sport _____

Some of the things that make my mom special are:

When my mom was a baby, she looked like this:

MY DAD
Here is a photo of my dad:

My dad's full name is _____

He was born on _____ in _____

His height is _____ , his eye color is _____ , and his hair color is _____

He has _____ sisters and _____ brothers, and they were born in this order:

He grew up in _____ and went to these schools:

After school, he _____

When my dad was a young man, he dreamed of _____

Some of my dad's favorite things are:

artist _____

book _____

color _____

film _____

flower _____

hobby _____

holiday _____

place _____

play _____

season _____

song _____

sport _____

Some of the things that make my dad special are:

When my dad was a baby, he looked like this:

MY PARENTS' COURTSHIP AND MARRIAGE

Here is a photo of my mom and dad before they were married:

My parents met on _____ at _____

My dad's first impression of my mom was _____

My mom's first impression of my dad was _____

The things they really like about each other are _____

My parents were married on _____ at _____

Here is a photo of my mom and dad on their wedding day:

My siblings' names and ages are:

Here is a photo of my brothers and sisters:

MY MATERNAL GRANDPARENTS

Here are photos of my mom's mom and dad:

My Grandma:

My Grandpa:

MY PATERNAL GRANDPARENTS

Here are photos of my dad's mom and dad:

My Grandma:

My Grandpa:

MY FAMILY PHOTOS

WAITING FOR ME TO ARRIVE

My mom found out she was pregnant on _____

Her reaction to the news was _____

My dad's reaction to the news was _____

The first people who heard about me were _____

My mom's due date was _____

My mom first heard my heartbeat on _____

She felt me kicking on _____

My dad first heard my heartbeat on _____

He felt me kicking on _____

Before I was born, my parents liked to call me _____

Here is a photo of me before I was born:

[Paste ultrasound photo here]

While carrying me, my mom craved _____

And she couldn't stand eating _____

Here are some photos of my mom before I was born:

A BABY SHOWER

_____ hosted a baby shower on _____

[Paste shower invitation here]

GUESTS	GIFTS	THANK YOU NOTE SENT

THE DAY I WAS BORN

My mom went into labor on _____ at _____ o'clock.

At the time she and my dad were _____

The labor and delivery lasted _____

I was born on _____ at _____ o'clock.

When my mom first saw me, she _____

When my dad first saw me, he _____

When my mom first held me, she _____

When my dad first held me, he _____

When I was born, I weighed _____ and was _____ inches long.

I had _____ eyes and _____ hair.

Special things my mom and dad noticed about me were_____

My mom thought I looked like _____

My dad thought I looked like _____

Other people said I looked like _____

Here is my hospital bracelet:

Here are some photos of me right after I was born:

THE DAY I MET MY MOM AND DAD

I first met my mom and dad on _____

at _____

When my mom first saw me, she _____

When my dad first saw me, he _____

When I came to live with my parents, I was _____ old.

I had been living in _____

This is the story of my adoption _____

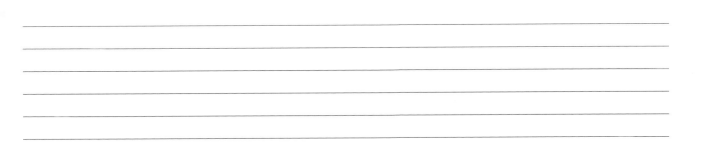

Here is the first photo my parents have of me:

Here are some photos of me with my parents on the day that we met:

MY NAME

My parents chose my name because _____

The meaning of my name is _____

My nicknames are _____

Some of the other names my parents considered are:

BOYS' NAMES GIRLS' NAMES

MY TINY HANDS AND FEET

Here is my cute footprint:

[Paste footprint here]

Here is my adorable handprint:

[Paste handprint here]

MY BIRTH ANNOUNCEMENT

[Paste birth announcement here]

THE WORLD ON THE DAY I WAS BORN

On the day I was born, the weather was _____

The president was _____

Some important local and national events were _____

Some important world events were _____

Favorite movie stars were _____

Hit movies and television shows were _____

Popular singers and songs were _____

Best-selling books were _____

Prominent sports figures were _____

Some fashion fads were _____

Some prices of things were _____

[Paste newspaper headlines here]

MY MOM'S MEMORIES OF MY BIRTH AND FIRST FEW DAYS

MY DAD'S MEMORIES OF MY BIRTH AND FIRST FEW DAYS

Here is a photo of me with my mom:

Here is a photo of me with my dad:

MY HOME SWEET HOME

My mom and dad brought me home on _____ at _____ o'clock.

At the time, my family lived at _____

When we arrived, we were greeted by _____

Here are some photos of my homecoming:

Here is a photo of where I live:

Here is a photo of my nursery:

MY FIRST VISITORS

My first visitors were _____

They thought I was _____

NOTES ABOUT MY FIRST WEEK AT HOME

Here are some photos of me during my first week at home:

ROCK-A-BYE BABY!

Lullabies my mom and dad sing to me are _____

My sleeping schedule and habits are _____

To help me fall asleep my mom and dad _____

The first time I slept through the night was _____

Here is a photo of me asleep:

MEALTIME!

I first ate solid food on _____

My favorite foods are _____

My least favorite foods are _____

I first held my own bottle on _____

I first fed myself on _____

Here is a photo of me eating:

OUT ON THE TOWN!

The date of my first outing was _____

I went to _____ with _____

I reacted by _____

Here is a photo of me on my first day out and about:

RUB-A-DUB-DUB!

I had my first bath on _____

I reacted by _____

Things I like about taking a bath are _____

Things I don't like about taking a bath are _____

Here is a photo of me in the tub:

MY FIRST HAIRCUT!

I had my first haircut on _____

I reacted by _____

Here is a lock of my hair:

MY FIRST TOOTH!

My first tooth appeared on _____

SOME OTHER FIRSTS

I lifted my head up on _____

I rolled over on _____

I sat up by myself on _____

I crawled on _____

I pulled myself into a standing position on _____

I took my first step on _____

I walked from my mom to my dad by myself on _____

I clapped my hands on _____

I waved bye-bye on _____

I played peekaboo on _____

I threw an object on _____

Other physical firsts of note:

MY EXPRESSIVE FIRSTS

I first smiled on _____

I first laughed on _____

I first made cooing sounds on _____

I first imitated sounds on _____

I said my first word on _____

My first word was _____

My first phrase was _____

Other expressive firsts of note:

A RECORD OF MY FIRST WORDS

WORD	DATE SPOKEN

Other funny things I said:

HAPPY HOLIDAYS!

My first holiday was _____

My family celebrated by _____

I wore _____

Here is a photo of me on my first holiday:

FIRST DISCOVERIES

When I first rode on a swing, I _____

When I first went swimming, I _____

When I first saw snow, I _____

When I first heard thunder, I _____

When I first ate ice cream, I _____

When I first ate cake, I _____

Other first discoveries:

SOME OF MY FAVORITE THINGS

Activities _____

Animals _____

Bath toys _____

Books _____

Nursery rhymes _____

People _____

Songs _____

Stories _____

Stuffed animals _____

Television programs _____

Toys _____

Treats _____

Videos _____

Some of my other favorite things are:

INCHING MY WAY UP!

DATE	AGE	HEIGHT	WEIGHT

VISITS TO DOCTOR

DATE	REASON FOR VISIT	COMMENTS

A RECORD OF MY FIRST YEAR

Here are some more of my first photos:

MY PHOTOS

89

6TH MONTH

MY PHOTOS

8TH MONTH

MY PHOTOS

HAPPY BIRTHDAY! MY FIRST BIRTHDAY

[Paste party invitation here]

We celebrated my first birthday by _____

What I thought of the party, cake, and candles: _____

GUESTS GIFTS

MY BIRTHDAY PARTY PHOTOS